Forty Lies

JOHN GALLAS was born in 1950 in Wellington, New Zealand. He came to England to study Old Icelandic in 1972, and stayed. He has been a teacher of children with special needs for twenty years, most recently with the Leicestershire Student Support Service. John Gallas has published six earlier collections of poetry with Carcanet and edited the anthology of world poetry *The Song Atlas* (2002).

SARAH KIRBY has been a practising artist for twenty years. She is primarily a printmaker, and has been a studio member of Leicester Print Workshop for fifteen years. She also paints and makes books, and undertakes teaching and curating. Her work has been widely exhibited.

Also by John Gallas from Carcanet Press
Flying Carpets over Filbert Street
Grrrr
Practical Anarchy
Resistance is Futile
Star City
The Book with Twelve Tales

As editor
The Song Atlas: A Book of World Poetry

John Gallas

Forty Lies

With illustrations by Sarah Kirby

CARCANET

First published in Great Britain in 2010 by
Carcanet Press Limited
Alliance House
Cross Street
Manchester M2 7AQ

ISBN 978 1 84777 049 3

The publisher acknowledges financial assistance from Arts Council England

Supported by
**ARTS COUNCIL
ENGLAND**

Typeset by XL Publishing Services, Tiverton

Printed and bound in England by SRP Ltd, Exeter

Contents

It is the job of the poet to invent beautiful falsehoods

Umberto Eco

George, son of Captain George Malzard, died Foochoofoo, China,
15th October 1871, aged twenty-four

Memorial on the wall of St Peter's Church, Jersey

a long, spick field:
something growing:
thick-ranked, harled,
limegreen, litup stripes
of hot water
in mustard mud:

a heavy horse:
the air argues:
faces pushing in
clingfilm:
steamrings swish
and splosh:

a leather, stirrupped boot
that sweats
through polish:
drizzled specks of
mudspurt:
and on one rides

a little, interested insect:
the bootrim
and the leg: which brilliant
brown between
corduroy and joint
it drills sszzz:

a short slap and frown:
the heavy horse humpfs swoosh
upoff the field:
and he, the man, the insect's
swollen speech-balloon,
starts a gallop.

In 1968, in Mexico City, Mongolia's first silver medal was won by
Munkhbat Jigjidym in the middleweight (up to 87kg) freestyle wrestling

Entry in 'World Sports' magazine

The air up
here is woozy,
shallow, sweet,
but not so…um
head–clear.
Clear up a green, high, home hill,
bear-tangled with wind, the here-air
heartens my head. Up and down a numb,
bleach mat, hugging souls here, souls that
bow grass down, that clog clouds,
that wilt wind a whole day's horse
ride. *I eat all comers, faces* like
bubbles *in new cheese, muscled* *as milk*
and *wrestling shadows: keep* hold
of what is bad, boy, and throw
it down. The air up here is
woozy, shallow, sweet, but not
so…um head–clear. One foot, one grab
out! up! down! a numb, bleach mat.
Falls on all this green, high, home
hill. Hold what is bad, and down.
Sleep and *live with*
it hidden *and held.*
The air *is clear*
sweet: take it *down to what*
it is. I hold my own soul,
that hangs on my *belt while I sing.*

The twelve entries for the music to New Zealand's National Hymn
were judged by a panel of three German musicians in Melbourne (1876)

Entry on 'Oldpoetry' website

Three brown beards at a big gum table,
Six brown boots on a big gum stage,
One brown box with an En Zed label,
One white Anthem on every page.

Rain beats down on the blue gum Opera,
Rain beats down on the Melbourne mud;
Oompah oompah statelier and properer,
Oompah oompah wilderness and blood.

'Vot about zis ?' – bung bong bang bing,
'And vot about zis ?' – toodle-pom swish-swoosh;
And the big black Bechsteins tinkle and sing
Like wind-up birds in the big black bush.

And they play and they play till the rain goes away,
And the big wide landscape shrinks to a Hymn,
And they light their pipes and smile. Hurray,
Hurray, Hurray. And the sea goes dim,

And the mountains gleam, and the pungas slap,
And the broad bright rivers crash along,
And the flax-straps hiss and the keas flap,
And the bush yells back with its own big song –

God of Nations, at Thy feet,
In the bonds of a big brass band,
Hear our voices we entreat,
God Defend New Zea-ee-land.

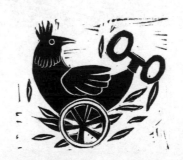

Let-we Thon-dara (*fl.* 1752–83). Composer of two famous *yadu* written in exile at Me–za, describing his unhappiness in terms of such pathos that the king is said to have ordered his immediate recall

From 'The Penguin Companion to Literature', Volume 4

No postman ever comes here.
Hotdrops flop off the elephant-trees
in letter-shapes.
They drop so slow I can see myself
in each one – fat, still and silver-gloomy.

No yellow ever comes here.
The bright monkey-rolling sea
of jubbahs.
Hot fog shifts like its ghosts
through my verandah – ashed, lightless and silver-gloomy.

No brain ever comes here.
My thoughts are a bamboo thicket-click.
I live and think
in the hair of my green porcelain monster,
my slippers on its skull, cold and silver-gloomy.

No lute-bell ever comes here.
Hap-rhythmned rain, the unsorted racket
of this place's earthsong.
I think of its sweet measured twangle
that was my soulsong. I am sick and silver-gloomy.

No picnic ever comes here.
Matleaves sewn with spider-warp
snakes eat on, ugh ugh.
Sundown that honied our
pies and punch beams slime and silver-gloomy.

No honour ever comes here.
Slugdog eats slugdog. It is unknown
to know what Good is.
There is only one reason to be a man:
I sit here still to hold it, memoryfull, fat and silver-gloomy.

Ah, you never come here.
I'll write you a complaint, and send it
oh…by tigerback.
Ah! I've done it. Where's the tiger?
Rescue me please. The moon is clean and silver–gloomy.

Mardukapal–Iddina II (772–710 BC) of Babylon built a garden where sixty-four species of medicinal plants were grown

From 'The Dictionary of Herbs'

marrow.dill.opiumpoppy.mandrake.apple.alkanet.aconite.bu
rdock.lavender.bellbine.garlic.horseradish.wormseed.marsh
mallow.coriander.hops.feverfew.gentian.horehound.pineresi
n.juniper.oleander.box.mustard.liquorice.purslane.southern
wood.hellebore.pomegranate.sneezewort.bearberry.wormw
ood.angelica.foxglove.caraway.cucumber.fennel.myrrh.onio
n.rose.saffron.hemp.henbane.glasswort.galbanum.yarrow.agr
imony.tarragon.bogbean.mugwort.asarabacca.borage.chamo
mile.chicory.hemlock.peppermint.lemonbalm.toadflax.eleca
mpane.rue.larkspur.cumin.asafoetida.eyebright

The builders, for Mardukapal–Iddina II surely did not make this garden himself, left this key to a secret message hidden within the Royal List of Contents of the herb garden:

1.1.2.3 / 2.1 / 3.4 / 4.7 / 5.1.2 / 6.1.2 / 7.5 / 8.4 / 9.6 /
10.6.7 /11.2 /12.1.7.8 / 13.4.6 / 14.1.2 / 15.7.8 / 16.4 /
17.2.3.4 / 18.7 / 19.5.7.8.9 / 20.5 / 21.6 / 22.6 / 23.1 /
24.2/ 25.7 /26.5 / 27.12 / 28.5.8 / 29.0 / 30.1 / 31.0 /
32.0 / 33.5.6 / 34.8 / 35.0 / 36.0 / 37.0 / 38.0./ 39.0./
40.0 / 41.0 / 42.0 / 43.0 / 44.0 / 45.0 / 46.0 / 47.0 / 48.0
/ 49.0 / 50.0 / 51.0 / 52.0 / 53.0 / 54.0 / 55.0 / 56.0 /
57.0 / 58.0 / 59.0 / 60.0/ 61.0 / 62.2.5 / 63.9 / 64.3.5 /

Picard, Auguste Antoine (1884–1962) and Jean Felix (1884–1963),
Swiss, explored the stratosphere by balloon

From 'The Penguin Book of Facts

Two stout wartrees prop the sky.
Some city, veined as a skinned patient,
draping there, breathes a river.

The Picards' silver balloon, a lung-bubble,
pops off a wharf. Wobble-growl. Up,
up. The world and its works unmash

into a picture, stopped with sweet wind.

Two duckquilt coats with wadded muffs,
rubber goggles, woolhoods, energy-chocolate,
rising…and the Thermos hissing…rising…

softly through a plate of frosted glass,
wobble-growl and ozone-champagne fizz,
into no weather and a lemon calm.

The Picards unscrew their tortoiseshell pentops.

Now man is a proud sort of creature.
He will measure, christen and explore
to be master of rabbits, baobab trees, oceans and stones.

He drags the world to his bosom
because it does not care, and names it Love.
In a land of silent air, the Picards make notes

to claim the stratosphere, and make us men.

...the beautiful youth whom Saadi encountered at Kashgarh...was the famous poet of Dihli, Amir Khusrau

From an introduction to 'The Gulistan of Saadi'

Six a.m. and I'm ready to die:
chasing a black butterfly.

I mean in the meaning of leaving life:
I mean leaving the love of it.

A poor man came into a beautiful garden and mistook it for Heaven. 'I shall stay here,' he said. 'What would be the sense in leaving?' He sat there for a month under the rose-bushes, and eventually died of hunger. When he awoke, he was still in the garden. 'Now I am not hungry anymore,' he said. 'How profitable it is to die!'

A garden is man's account of nature:
which is what our souls may be:
which is what we leave life to have.

You are beautiful: why would I walk away?
You have come and gone in a moment: I shall stay.

A pious man was sitting in the desert when a prince rode by. 'Why do you sit here alone?' said the prince. 'I am looking for God,' said the man. 'You will not find Him in nothing,' said the prince. 'I have a beautiful garden in Kashgarh – come and look there.' So the pious man climbed up behind the prince and they rode back to the city. When the pious man saw the prince's garden he sat down and wept. 'God is not here,' he said. 'Only the poor, wretched creature that is me.' 'That is well said,' said the prince. 'Now He is nearer than you think.' And he gave the pious man his coat.

I thought that I would
have to forget God
to remember you:
but it isn't true.

In January 1906, Maria Spiridonova assassinated Police Inspector
Luzhenovsky

From 'Revolutionary Russians

Luzhenovsky left the meeting late.
He slammed some doors. Security was tight.
It trotted round his legs. His face was white.
Some Angry Thing. His golden watch binged eight.
The moon looked down and splashed the marble stairs.
He stomped, they pattered down. She tiptoed up.
A pistol in her glove. She shot him. WHUP!
WHUP! He burst with blood. She said her prayers.
Thank God, one ogre less: the scale of love
comes down one inch. He fell. Thy Kingdom Come.
Security attacked her legs. The numb,
dumb, hardboiled moon looked down. She dropped her glove.
All the bloody world knows right from wrong.
God bless the straight, white mind: God bless the strong.

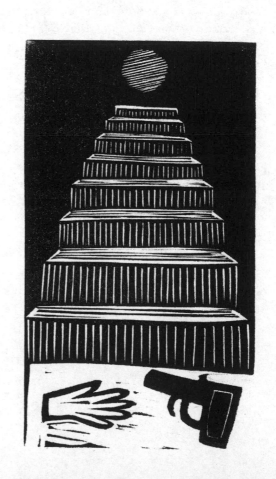

Nerval paraded the gardens of the Palais-Royal with a lobster on a pale blue ribbon

From an introduction to 'The Poems of Gerard de Nerval

Limetrees bob like sponges in the gloom.
The blue blue benthic air rolls cold but kind.
The beds blip mud. A billow-brine perfume
balms the brain and buoys the squally mind.

Cold is safe. Gee-up, Aegisthus. Click.
Click. Damask castanets – click-clack –
and boxing roses. Darling, scuttle quick,
the sky is spitting and the moon is black.

Tell me, sweetie, while we inch along
the shrubbery, what happens when the sea
is on your head, and how the mermaids' song
makes stars; and all your liquid history.

Don't let me fall to pieces. Cold and slow,
Aegisthus dear, our brains won't drift away.
Good evening, various Friends and Fish. We know
that life is cold and dark and deep. Let's pray.

O mighty Tefrut, be with us tonight.
Don't let me be mad. Please hold my hand
and guide my trip and toddle to the light
of morning, and the nearly-promised land.

Limetrees bob like sponges in the dark,
whose high-tide fills the city. Birds breathe quick
as ripples. Little heartbeats shake the park.
Something spilled shines on the gravel. Click.

For his Islamic enthusiasm, on the other hand, (William) Whiston was expelled from Cambridge in 1709

From 'Orientalism' by Edward Said

My slipper'd tootsies roost along the grate.
The *damask* kettle sings. I conjugate
Moroccan verbs. My *iznik* coffeepot
Exhales the niff of Heav'n. The stairs do not.
Lokum twinkles on a *tunis* plate.
I puff my hubble-bubble. God is Great.

Outside, the fatuous, wat'ry *english* night
Cow'rs beneath the moon; the *Nazarite*
Dribbles in his tea; the captious wind
Persuades the *englishman* that he has sinn'd;
& wheezing organs, pinchèd guilt and sh–t
Deform the *Heart* into a *Hypocrite*.

I close the *baghdad* drapes. The clock chimes *Eight*.
I'm seventeen. It's dark. I contemplate
The Life to Come. My fretted *balkh*-lamps shine.
The rain drips down. I hear the sodden whine
of *chapel hymns*. I suck a *shiraz* date.
My tootsies glow and wiggle. God is Great.

Mirsaid Mirshakar, People's Poet of Tajikistan: first work to appear in print was 'The Banner of Victory' (1934), concerning the irrigation of the Vakhsh valley

From 'Voices of Friends

Once upon a time I lived in a big, yellow house with two big, blue wooden pillars at the front door. There were two brownish goats and five fat, feathery chickens that all lived together in the big, brown yard. There were three shiny lemontrees in nice green painted pots under the big window, and a pretty, green, painted, corrugated-iron fence to keep out the street. Inside there was a sunny, brown Quiet Room where I wrote my poems, with a puffing, shiny stove and clicketty Hero typewriter and a nice picture of the glorious revolution in a beautiful red frame.

Now I had been thinking for a long, long time about writing a nice, happy poem about the Vakhsh dam, but then something really, really interesting happened. And this is what it was:

I was sitting quietly in the sunny, brown Quiet Room. I was smoking a Red cigarette and stroking my best friend, BillyBob, who was lying fast asleep by the puffing, shiny stove with a sleepy smile on his whiskery face. I was thinking in a happy way about the glorious Vakhsh dam when all of a sudden my clicketty Hero typewriter went kak–kak–kak and spelt the word 'the' all by itself! BillyBob pricked up his fluffy ears and stared with his big, yellow eyes.

Now about an hour later, when it was nearly time for dinner and BillyBob was washing his fluffy ears and the lovely smell of turnip and gudgeon soup was wafting and wifting off the puffing, shiny stove, the clicketty Hero typewriter went kak–kak–kak–kak–kak–kak–kak, and spelt the word 'Banner' all by itself! Now I had been thinking about Banners – red ones, people's ones, state ones, nice ones, waving, flapping, wafting and wifting – so I thought that maybe the clicketty Hero typewriter was maybe materialising the general consciousness of our Time, if you understand my meaning.

Now a little while later, when BillyBob was fast asleep again and I was smoking another Red cigarette, it went kak–kak and spelt the word 'of' all by itself! And then it went kak–kak–kak–kak–kak–kak–kak and spelt the word 'Victory' all by itself! Thus, dear reader, I took my chance to write a poem by remote control, and so be freed of the awkward burden and dangers of the responsibility of authorship. For three hundred nights my clicketty Hero typewriter wrote all of 'The Banner of Victory' with the exultant stutter of a machinegun.

As soon as it was finished, I took the long, lengthy poem to Mr Moleswerve, who lived at the People's Publishing Company, 44 People's Street, where the traintrack goes clatterclatter between the Butcher's and the Water Advisory Board Advice Centre, and I told him that the poem had been written, not by me, but by the Spirit of the People. Mr Moleswerve looked at the poem with his big, moley eyes and said that that was all right, and he would see to everything himself, which he added with a big, beardy smile. The small flutter of wounded pride that fluttered like a butterfly in my proud and happy breast should have been a warning to me to stay silent, and be proud and happy.

But, dear reader, I did neither. In the end, unable to resist, I asked for my name to be put with the title of the long, lengthy poem. In the first month of Mr Moleswerve's publication of the poem I was given a People's Culture Medal, a Well-Done Scythe, and an invitation to an Artists' Dance in Kazan, which I could not attend.

By the third edition I was caught. I had used a Tajik word. I had weighed my praise injudiciously. I had misnamed a tributary. I don't know. Anyway, I received a nasty, grey letter calling me a recidivist. But no one came.

And now I have this strange, recurring dream. BillyBob is clawing at the broken, brown wainscot. My clicketty Hero typewriter is going kak-kak-kak all day and all night. There is nothing I can do. And some cold, new flat somewhere is piled high with bourgeois, dreamy, neurotic, egotistical poems in byzantine verse-forms. The brown goats are staring in at the little windows. The feathery chickens are perched on the puffing, shiny stove and staring at the door with their little green eyes. I am sitting in my new metal chair, smoking a Red cigarette. And I fear a velvet knock on the door.

The first sheet-paper-making machine was successfully operated by
Louis Robert in 1799

From 'Paper Works'

(a–Gubba Gubba squeechy squeechy drip)
We have le papier automatique –
the sweet white sky of squiggled scholarship!

We gaze agog. The floppers flop and flip,
the spindles spin, the rumblers buzz and squeak
(a–Gubba Gubba squeechy squeechy drip)

S'il vous plaît, Alphonse – a paperclip!
Now take ma plume and blacken with its beak
the sweet white sky of squiggled scholarship!

Ah, thus was Heaven's short companionship
with pureté undone: and thus Men speak –
(a–Gubba Gubba squeechy squeechy drip)

Je vois a million inkpens hover…dip –
and blackbirds, vultures, crows and ravens streak
the sweet white sky of squiggled scholarship!

More rags, Alphonse! More rags! The readership
of Hell demands its Heav'n. C'est magnifique! –
(a–Gubba Gubba squeechy squeechy drip)
the sweet white sky of squiggled scholarship!

23 March 2005: Associate Professor Hulya Tezcan. This lecture provides a fascinating look at some eighty talismanic shirts…which were believed to ward off all sorts of evil spirits and restore the health of the ailing

From the Turkish University lectures schedule

Exhibit 1114cx721/B. Linen, with leather, lapis lazuli, silver, tin, string, paper, ink, silk, wood, copper, cotton, pearl and eyelash.

This handsome talismanic shirt dates from 1515, and may have belonged to Sultan Selim I. It carries eleven written talismans, two stamped metal talismanic badges, a lapis lazuli stone, and one silver-boxed relic.

1. The linen fabric.
Though thin in places, this is well preserved, and has no tears or holes. It is in the cross-woven Kutahaya style much favoured by the wealthy and powerful, as its double weave was prized for its softness and durability.

2. The pearl buttons.
Rare at the time, pearl decorations in the form of buttons and/or beads were the preserve of the Sultan and his family. One particularly fine and large button, 3cm in diameter, secures the high neck of the shirt. There are seven buttons down the front of the shirt, and two at each wrist, placed consecutively. These eleven buttons all measure 1.7cm in diameter and have a double ridge around the circumference, front and reverse.

3. The three talismans stitched on with cotton thread.
(a) left shoulder front and back. A leather rectangle 17.2cm × 11.1cm. Ink writing: *On earth and in yourselves there are signs for the true believer. Can't you see them?* (Koran: The Winds).
(b) right front middle. A paper rectangle 21.1cm × 9.0cm. Ink writing: *Nature, not spite, gives the scorpion its sting* (Proverb?). The paper is badly worn and lined horizontally from repeated folding, probably by the sitting/leaning forward of the wearer.
(c) left cuff (all around). Pink silk (slightly faded). 4.2cm wide. Ink writing: *My friend, we ride through a hard landscape* (Qatran: Tabriz).

4. The five talismans hanging from the shirt on lengths of string fixed at each end by cotton cross-stitches.
(a) right shoulder front. A paper oval 8.2cm × 13.8cm on 3.1cm string. Ink writing: *This prayer you make* is *the reply from God* (Rumi).
(b) right shoulder back. A paper oval 13.2cm × 21.4cm on 6.6cm string. Ink writing: *Heavy rain and wind are the ways clouds look after us* (Rumi).
(c) left front. Large leather rectangle 24.4cm × 19.8cm secured by 3.3cm string top, 3.2cm string below, and 2.8cm strings to each side. Ink writing: *God does not go wrong, and He does*

not forget. It is He who made the world your cradle and made paths on it for you to walk on (Koran: Ta Ha).

(d) right cuff front. A small wooden square 4.0cm × 4.0cm on 2.6cm string. Ink writing: *Save, Saves, Saved, To Save, Saviour* (Unknown).

(e) right cuff back. A small wooden square 3.8cm × 4.0cm on a 2.6cm string. Ink writing : *Protect, Protects, Protected, To Protect, Protector* (Unknown).

5. The three talismans pinned on with copper pins.

The six pins (one top, one bottom on each talisman) all measure 6.2–3cm, and are threaded twice through the talisman/shirt in each case.

(a) right front bottom hem. A thin wooden rectangle 7.7cm × 9.1cm. Ink writing: *An innocent man goes only to the foot of the scaffold* (Proverb?).

(b) back right panel. A large paper rectangle 32.1cm × 17.9cm. Ink writing: *Pure gold fears nothing from the earth* (Proverb?).

(c) back left panel. A large paper rectangle 32.0cm × 18.1cm. Ink writing: *Don't go for the doctor, go to the man who knows* (Proverb?).

6. The two stamped badges hanging on string fixed on by cotton cross-stitches.

(a) left centre front hem. A small tin badge, circumference stamped with a circle of small crosses. Fixed with 2.2cm string through a small hole on the top of the badge. Stamp resembles the shape of an apple. Meaning unknown. (Health?).

(b) right centre back. A small silver badge, fixed with 3.1cm string through a small hole on the top of the badge. Stamp of face in profile. Shaved head. Prominent nose. Bulging eyes. Meaning unknown. (Disease?).

7. The lapis lazuli stone.

Fixed with a woven silk plait (cobalt blue/3.9cm) and net to neck button. Kidney shaped. Uncut (?). Approx 5.2cm × 3.0cm. A stone associated with Paradise and clarity of thought.

8. The silver-boxed relic.

Hanging from back centre 'collar' on woven silk plait (cobalt blue/6.1cm) cross-stitched to neck fabric and affixed through semicircular wire on top of silver box.

(i) the silver box. Like a small modern suitcase. 5.0cm × 3.1cm × 2.0cm deep. All surfaces plain, undecorated, dull silver. Top opens on single pin-hinge. Within

(ii) lined with decayed blue/turquoise silk. Small piece 3.7cm × 3.2cm of blue/turquoise silk folded (corners to centre, resulting shape folded in half) around an eyelash. Now stiff and grey.

This shirt would have been worn over other clothes in times of need and ill-health, and is thus large and loose in design, reaching to the wrists, down to the genital area, and with a high, buttoned neck. This style is known only in this kind of shirt.

75th Anniversary of the Calamitous Burning at the Drumcollogher Cinema

Newspaper headline on the wall of a Drumcollogher bed and breakfast

Disbelief like at the Miracles, lightsout and ssh it's starting,
Rolls up in the curtain on a whirring breath
Undominoed dustrose bandaged bound and pinched.
Monday 6.30 'Why Worry ?' One Night Only, O Lord we will not. The pennies, the
Cold, the tongue and the labour slug as leather shoes
On lightless mud and O Lord the swimming happy
Lost damned thinking thinking damned and glass water
Level in the heart and laugh I nearly burst my buttons
O Lord the joy of it, hardly ever and or but with You, O
God not yet, all waiting white to catch fire when
Harold gets the giant's tooth and there is peace to come.
End, the end, ssh it's starting, dustrose burning
Rolled up in the curtain, disbelief like at the Miracles that man
Can burn and Mary too, Why Worry O Lord we will not.
I sit at the calamitous cross all grey and cold and
Now the pictures roll, ssh it's starting, pictures the burning heart lightsout and the
Earth that left us and the whirring breath. O Lord
Make them rest easy who are burned so bad and cannot lie.
Amen.

Askhabad. Capital of Turkmenistan. Rebuilt to withstand earthquakes
since 1948 disaster. Silk, cotton, carpets

From 'Philip's World Handbook'

Another shaker! Rolls up like a catback
in honk-throes. Blocks of flats, their faces
made-up with sunshine, chatter till the crack
of Partytime enhulas them: staircases,
showers, balconies and cupboard spaces
undulooloolate their plastic spines.
The clouds are fluff. The honey sun-day shines.

And Man, who made them, shudders in the streets,
with all his other fears intact – his weight,
his car, his heart, his job, his small deceits,
his holiday, his dog, his God, his Fate,
his bed, his grave, his memory, how great,
how soon forgot – and waves his handkerchief
against the dust of ages, bright and brief.

And all the buildings dance the Partyquake,
the skirty carpets waving in the heat,
the golden cotton scarletsilken shake
of careless stuffit rocking manmade concrete
hulaloola cando bedo beat
on faith on hope on physics strength and dreams.
The clouds are fluff. The honey sun-day gleams.

I got him downstairs to a back room and the first thing he said was, 'Jock, I'm ashamed of the state I'm in'. He put both hands over his face and cried like a child.

John Bruce about T.E. Lawrence, in 'The Secret Lives of Lawrence of Arabia

Tom's spent. His cum please
hid in his hand :
and snailaway his penis
down the grey
prickly blanket.

What is beaten out
still lets the golden mind…

Tom's to blame. His arse please
torn in the air:
balls belled close by
bloodstuck wet
and falling in.

What runs out
still lets the library mind…

Tom's sorry. His belly please
aflutter and spit:
and nipples nearly white
pinkenscratch
gall past cumming.

What leaks out
still lets the ivory mind…

Tom's ashamed. His eyes please
sink in their tears:
a lashblink throws them out,
his body is not
him again.

What spills out
still lets the noble mind…

Pedro Alvarez Cabral: celebrated Portuguese navigator
*c.*1467–*c.*1520…Of his later life, nothing is known

From the 'Catholic Encyclopaedia' websit

I'me fortie nowe. I ake. Theye thinke I'me dedde.
I puffe my pype. The fyre brekes lyke glasse.
The worlde I sawe has shrunke ynto my hedde.
Bellem, the raine, the Seaphants, Vinh, Maddrass,
Ah Godde, I'me tyred. The olde flaymes dysappere.

Ower lyves beginne confyn'd – the wombe, the bedde,
the roome, the howse, the worlde: and nowe I'me heere.

I lyv'd one brethe – oute, inne. The white sayles spredde
and furl'd. The ocean sayl'd and loste. The brayve,
the noble deedes, the endlesse promysse donne.
Thys worlde, thys howse, thys roome, thys bedde, thys grayve
The fyre ys oute. The yron rounde ys runne.

I bowe to Godde's ynevytable pow'r.
I thanke Hym for my necessarie hour.

After going through some wonderful performances, the Elephants
left the arena and the Famous Boxing Match was next introduced,
Man vs. Kangaroo

From the 'Pan American Expo Diary'

Der hall is all dun chockablock
an all der mens go *ooo* and *SSSH*:
der shef-der-joues go knock knock knock,
an give is alpenstock a SWISH.

Today e yell *youse lucky volks,*
we gorra boxin match wotLIKE
youse never speckled – okeydokes!
oi gives you Nose O'Blue an SPIKE!

Gerthud gerthud der big fett bloke
come stompin on, an flex an GLOWER:
we all goes *boo,* e punch, e poke,
e jab, e swing, e show is POWER.

Gerdoing gerdoing an Spike bounce in:
we all go *raaay* an Spike look ROUND,
an thump is tail an chuck is chin
an smile an then go boundy BOUND.

Der youman bean he wear silk pants
resemblerin a peacock's BUM,
is nose look like a elephant's:
we all go *harharhar*. Der DRUM

go bang bang boom, der shef-der-joues
say *box,* we all goes *Spikey SPIKEY!*
Some twat cheer for Nose O'Blue
an off they goes.Oh mikey CRIKEY!

What a slappy cracky smackin,
what a rollick bollick CRASHIN,
what a biff bang wallop whackin,
what a stickin kickin BASHIN!

Round dey bounces, weavin, bobbin —
smack! der fett man get a PUNCH IN:
Spikey do some tricksy dobbin
an foot der youman in der LUNCHEON.

Darn e go: we all goes *raaaay*
an up e get: we all goes *BOOOOO*:
der shef–der–joues go ding dong day —
it's one round to der KANGAROO!

Der second round go much more wicious.
Bluenose smack ole Spikey's EAR;
then e come on right flagitious:
Spikey totter. Some twat CHEER.

One round to der Youman Nose,
an one ter go. We thump us FEET:
Spikey Spikey! Off they goes.
Pingpong ! Nosey's boxin NEAT:

E's landin punches ere and there
an Spike's atopplin back an BACK:
e's darn! Is bits is everywhere!
e's boing! e's up! an boing SMACKSMACK —

it's bofe feet in der Tripes! *Hurray!*
An Nosey's silk pants hits the DUST;
is nose go thwang! an there e lay,
breffless, battered, beat an BUST.

An Spikey win the Expo prize:
e bounce an bounce around der RING,
an liddle tears come out is eyes,
an we go *raaay* like ANYTHING.

An Spikey win a motorbike
and gorris picture in der NEWS;
an e's der daddy, we love Spike,
cos we's all bloody KANGAROOS!

Laika was the first living creature to orbit space…and…the only creature knowingly sent into space to die

From the 'Memorial to Laika' website

snuffle
the quiet dirt
where a day looks
doggy life
to make mo
nothing else of
visible purpose
to man

except to be
useful to man
but the purpose
of a doggy life
is to make more do
like men make
more men

some dim truth
how can this be the purpose
of a doggy life
when a million dogs
are no use to men
and a million live and
unseen by men

some dim truth perhaps
the doggy does for men
what men need
to lie them
beyond the fact
that it is just all
making more

such as honour courage
glory knowledge history
which are made
who are themselves
rage jealousy disgust a
terror warm tears for
when death is done

o man for it is easy
to kill a faithful servan
for he can be ta
to pull the trigger
poor old Barker
when love returne ant
more life but death

at least let us not say
confused afraid deserted
worried brave heroic
panicstricken no
doggy words but w
made by men who
that they have sent

something for them
on the long dark journey
they do not dare to make
but know they will ma
the dark the round the dark
where forever has no end
unlike the dark before birth

Feudal lord and senior cleric Noyon Khutayt Ravjaa (1803–1856) contributed to the Mongolian lyric genre. His songs 'Fair Wind', 'The Charming' and 'The Four Season of the Year' and many others have been sung by generations of Mongolians

From 'Mongolian Literature: A Guide

Fair Wind

I am seeking my fortune.
The birds speak a different language.

I can smell home.
Wind walks across the long green plains.

They will be cutting the wheat.
The sky is white, withdrawn.

The wind lifts night to its place.
I stride on in stardust.

The Charming

I was riding riding,
snow fell
like ashes from a fire
and I found my love.

I am riding riding,
ashes swirl
like snow from the sky
and I lost my love.

I ride ride,
ashes and snow,
sky and fire,
spellbound spellbound.

The Four Seasons of the Year

Spring hope
Summer work
Autumn thought
Winter death.

grass like green electric lights
wheat thrives because it is useful to men
I think it matters what I do
icegrass tinkles in the dark creek.

Still highly popular with readers are the didactic writings 'Negen ugsiin erdem' ('The Art of One Word')

From 'Mongolian Literature: A Guide

Chapter 102: Social Intercourse

1. How to blow your nose politely.
 Buff

2. Proper form of address to an older nephew (male).
 Lucid

3. Coping with diarrhoea in company.
 Rota

4. Maintaining decency in long-distance courtship.
 Memento

5. Insulting use of the horsehead fiddle.
 Bubble

6. Proper occasions for throat singing with advice on phlegm.
 Diligent

7. Probability of indecency in displays of contortionism.
 Oojakapivvy

8. How to manicure in groups.
 Ebb

9. Unpleasant body odour: a guide.
 Prolix

10. The limits of smiling.
 Halcyon

11. Sexual intercourse in subzero temperatures.
 Blossom

12. The art of floating testicles.
 Baffle

13. Meditation in the company of weeping babies.
 Majesty

14. How to safely enjoy a radio in a yurt.
 Vogue

15. Walking your camel: a chance to make friends?
 Flout

16. Horseriding in bisexual company.
 Reel

17. Newlyweds and yak indelicacies.
 Lull

18. Swimming: why?
 Jumbo

19. Conversation while eating in a nutshell.
 Column

20. Durations of appropriate hugging (clothed).
 Warp

21. How to urinate in strong winds.
 Eggshell

22. The limits of milk.
 Luminous

23. Bodyspace at the fireside.
 Adhesive

24. How to arrange breasts in the autumn.
 Jitter

25. What is love?
 Fortify

Saint Jose Cupertino (1603–1663): Italian monk who levitated in the presence of Duke Frederick Brunswick-Luneborg, who, despite being a Lutheran, found himself compelled to confirm the veracity of the miracle

From the 'Checklist of Levitations' websit

The Duke enters. Heavy people bow.
Weather pistons in the chimneybreast.
Extra candles watercolour noses,
steel, red brocade. A woman sneezes.

Rafters of cloud sit on the hunt lodge.
Ceilings of stucco deer-death sit on the walls.
The Duke sits. Chairs as big as beds.
Everyone sits. The scene is nailed down.

Earth flies among stars. Screwed tight
to its crust what man has built and been fights
some brave and stable course across the dark.
A bloodhound flops fat on the Duke's boots.

The fire pumps itself. A woman giggles.
The monk stands in the air. Only our minds
change: unanchored, like balloons cut
from a net, they worry at newness. Everyone frowns.

Shall every ship sail out now, and forget?
And every subject go its wandering way?
The monk's fingers rattle on the ceiling.
Rain soddens the earth outside, and roars.

The bloodhound humphs. A bit of decorating
and we can change religions. Something better
lives in men. Less airy love. The Duke
leaves. The monk floats among the deer.

WEKA (*Gallirallus greyi*). Can run very fast

From 'Native Animals of New Zealand' by A.W.B. Powell

Watch the WEKA run.
It's gone right past that MOUNTAIN
at a fair strop.

Hahahahahahahahahahaha.

It's got Auntie Noonie's
FORK in its beak. LOOKOUT!
I reckon it can't see where it's going.

Cool.

It's just gone round HOKITIKA
and out the other side. JEEZ, look at it go.
It's a CHOOK with a rocket up its bum.

Awwwwwwe-some.

Look at its mean laughing EYE.
I reckon it's going for takeoff.
I reckon it's leaving ah leaving the EARTH.

What a ripper!!!!!!!!!!

Listen to it HONK AAAARK
It's gone right through INVERCARGILL now.
Darling, wrap this cracked egg in your tongue.

Choice.

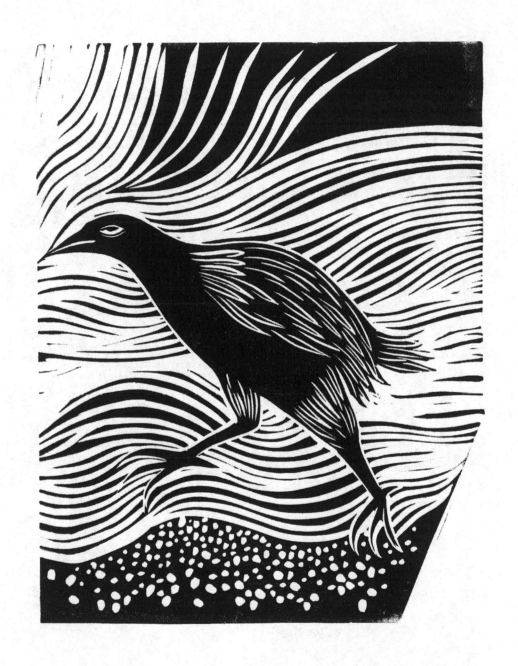

Posterity remembers Farouk as an obese debauchee who choked to death at the age of forty-four in a Rome restaurant

From 'Sultans in their Splendour'

The Whale Prawn, like a pink, broken quinquereme,
limps, bugeyed, in the cold cloy under Nuuk.
A milkyway of krill giggles up the Gulf Stream.

King Farouk tiptoes into a *bad*
at Baden-Baden. The Gods laugh. Their gold faces.
Glo-worms pump themselves chinesely in the Smoking Garden.

The prawn is bagged, o careful careful swish, and put on a plane,
and hums south buzz on a throne of bubbled ice.
Stars twinkle on propellers like fluffed cocaine.

King Farouk rubber-rolls over *Autobahn Ein*,
burning-cream, tight gut-tyres, laden loops.
Golden headlamps whizz athwart like gulps of sugarwine.

The giant prawn, blister-sealed, squeals flayed on a griddle.
The king's wingcollar, pressured flesh, nooses his neck.
And waiters ply like little galleons about the table-lands.

Farouk bugeyes the fat, pink, aspicated thing.
His tines prong the cold cloy, and gloop, slipout.
Red cigarsmoke bellydances up the Sultanic wallpaper.

The prawn, flop and pulsed goosey down the gullet-stream,
flabs champagnely, butter-squidge. The King falls.
Honk. Cat. Gag. Spew. Retch. Heave. Spurt.

The giant thing bops upup whale-scotch-spit neoned,
bounces gold across the carpet. The Gods laugh.
Two full stops. One bursts. The other food for fish.

The Ornithoptera goliath, found in New Guinea, is the second biggest
butterfly in the world

From the Honduras Butterfly Museum guide

Beautiful Apu died. We burned an aeroplane. Black ash-shape. It took off with his soul.

Alagiyavanna (*fl.* 1590–1620). Sinhalese poet. His principal works include the *sandesa* poem 'The Rooster's Message'

From 'The Penguin Companion to Literature', Volume

1

The Rooster is a Lovely Bird.
He tell the time. He keep his word.

He glare and struttle like a King.
He peck. He crow. He fight. He sing.

He rule the roost. He wise. He strong.
He shine like gold. He never wrong.

He watch the night. He praise the day.
He chase the devil-dark away.

He run like wind. He fly like cloud.
He jump the hens. He loud. He proud.

O Prince of Birds! O splendid-free!
Take this message! Fly for me!

2

The sun stands up – and Jaffna shines.
The saltfields buzz in sparkly lines.

The temples glitter. Parrots scream.
And men awake from dream to dream.

The blue lagoon blinks near and bright.
The city shimmers, wide and white.

Home of Heroes, Saints and Sages!
Awed and Honoured down the ages!

Heaven sways your palmy palms!
And holds your splendour in its arms!

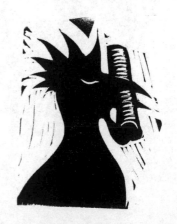

O Jaffna! Beautiful and Wise!
Out from your roofs the Rooster flies!

3

He flap along the Ando Way
And head for sunny Boga Bay

And then proceed to Temple Nu,
Singing cock-a-doodle-do!

He pass the Mill, the Elephant,
The paddy fields, he puff and pant,

He wheel above Banana Peak,
The message beakled in his beak.

He rush across the Field of Green
And down the Pretty Small Ravine

Towards the famous Egghead Dome
of Kandy, Rooster-Treats and home!

4

O Kandy! Raspberry and Gold!
Ages loved and ages old!

City of a million flowers!
Keeper of a thousand towers!

Peacocks, pools and golden bees!
Poets, parks and orchid-trees!

Orang-outang and Crocodile!
O Rajah of this City, smile!

From Mimbez to the Fat Sepoy
Your people love you. Live in Joy!

O Kandy! Gorgeous, matchless Prize!
Through your doors the Rooster flies!

5

He drop the message on a table.
Won the Butcher read the label.

Then he open it. *'My friend:*
You ask me how the World will End…'

He turn the page. He hold his breath.
He shake. He sweat. He scared to death.

The Rooster fluffle on the chair.
He puff. He pant. He scratch. He stare.

The Butcher wonder: Wind or Blood?
Curtains? Dragons? Fire or Flood?

'The answer is' – he read – *'Completely.'*
Rooster eye him sad and sweetly.

Ariwara Narihira (825–880). Japanese court poet. His poems are all *tanka*, which describe generally erotic incidents involving the hero, who is Ariwara himself

From 'The Penguin Companion to Literature', Volume

1

General Yodo
puts up his tent in the wood,
where it points at birds.

The lunchgirls flutter past me.
My cock puts up yellow silk.

2

I know a soft place:
a waterfall combs its hair
into a blue pool.

I am pretending to sleep
while she brushes her blue plaits.

3

Nightbird drawn on cloud,
cloud drawn on moon, moon on star.
I wait for some girl.

I have hidden my bright lies
with smiles, gifts, words and my cock.

4

My jaunting-car jerks.
I can feel my gorge rising.
I excuse myself.

I spurt onto the roadside.
As I would for any girl.

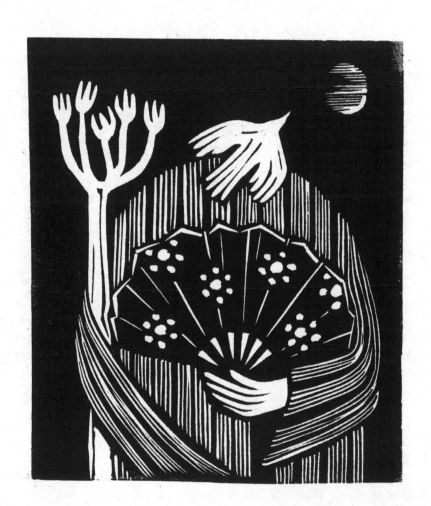

Saint-Saëns is purported to have danced with Tchaikovsky

From the 'glbtq arts' website

mm extensive notes extensive lie like soot like dust like soot deep soot deep on stage
busy busy music ah busy all that busy music on stage deep on stage broken broken on
stage fallen fallen deep ah fallen fallen flat the quiet pieces quiet pieces left lie like
soot lie like dust like soot like broken cover broken on stage deep on stage cover and
all about all dust all soot empty lie about all about nothing about maybe now maybe

maybe on stage now go go maybe now on stage a little ballet shoe little shoe a little
waggle ballet waggle shoe on stage now maybe now out out little ballet shoe out on
stage maybe now watching no nothing listening no nothing music no nothing all flat
on stage all broken broken cover nothing now maybe now a little ballet shoe out go go
mm waggle little ballet shoe nothing listening nothing music no maybe dust maybe out

no cover no no cover now go little ballet shoe little shoe go go now truth maybe truth
now maybe little truth broken cover yes watching no music no listening no nothing no
maybe truth now go go on stage now little ballet shoe waggle out go maybe now truth
no cover no music no watching no listening extensive notes broken now on stage truth
maybe now maybe extensive notes soot cover no fallen flat not now no truth maybe

tripping on stage little ballet shoe truth maybe now go go little ballet dress no cover yes
maybe truth extensive notes fallen flat not now go go all empty maybe truth now go go
little ballet shoe little ballet dress twinkle tripping waggle twinkle tripping now all about
nothing now music no watching no listening no truth maybe now twinkle tripping little
ballet dress little ballet shoe maybe on stage little shoe little dress twinkle tripping now

large man beard maybe truth maybe now large beard man twinkle tripping now maybe
heavy on stage heavy beard twinkle ballet dress ballet shoe little on stage large man
beard twinkling no music no listening no watching broken cover truth now maybe now
go go little twinkling large beard man ballet shoes ballet dress waggle tripping tripping
extensive notes music no maybe now maybe truth shift like dust shifting extensive notes

like dust like soot like dust no nothing now truth maybe twinkle tripping notes sssh now
truth maybe nothing sssh no music truth maybe now go go little ballet dress ballet shoes
waggle twinkle tripping large man beard heavy truth maybe now maybe on stage now
sssh nothing now truth maybe heavy man large beard tripping twinkle waggle ballet shoe
ballet dress music no watching no listening no truth maybe oh and a boot a boot waggles

a boot other side waggles twinkling flirtive waggle other side a boot truth maybe now
go go a boot other side waggle flirtive on stage music no fallen flat other side a boot now
truth maybe a boot waggle other side now flirtive boot waggle truth maybe ah ah twinkling
on stage ah together ah together twinkling ballet dress large man beard ballet shoes truth
maybe together ah together a boot tweedy suit smaller beard ah together ah together now

go go now together ballet shoes smaller beard ballet dress tweedy suit all together now go
twinkling together ah waggle tripping together all around twinkling tripping truth maybe
all together ah large man tweedy boot heavy together ah truth maybe music no broken cover
truth maybe now ah maybe sheer delight maybe twinkling shifting music dust broken cover
truth now go go ah together both together all around round and round sheer delight go go

cover broken both together all around round and round truth maybe music no watching no
listening no sheer delight round and round all round both together go go on stage now ah
sheer delight sheer truth maybe on stage large man heavy tweedy suit man man ah maybe
truth maybe sheer delight extensive notes fallen flat broken cover all truth maybe now ah
both together sheer delight truth maybe on stage ballet shoes boots ballet dress tweedy suit

twinkling music no watching no listening no broken cover truth maybe ah together man man
maybe twinkling tripping waggle ballet shoe boot ballet dress tweedy suit ah together now go
dust deep extensive notes shifting notes music no broken cover deep dust like soot like dust
deep truth maybe ah together twinkling tripping man man truth maybe sheer delight go go now
sheer delight ah ah ah ah both together all around round and round and round and round ah

1456. Pope Callistus III condemned (what has become known as) Halley's Comet as an agent of the devil

From 'The Catholic Calendar of Historical Events'

Make your poem from the words provided, as you make your life from God's provisions. Signed Callistus III & Muhammed Taragai (Ulu Beg)

Part 1: *Rome*

verse 1: the the the is of everywhere behind Rome Heaven Forum Spanish Steps Palace God Divine Agony clouds rain rain drainpipes sheep cows turnips hoods mankind squashed beats nibble clutter hangs gurgle riding – verse 2: the the the is a and that of down again nice sleet stone walls lust greed anger sloth pride covetousness envy jelly Bishops fire horse thunder chimney wine cake blood crucify dark morning Devil star line desire calls awake slatters flickery throbbles pass – verse 3: 37 the the the the the the I may is in in for of of why which item past please half fog mist hail consideration interpretation morning star night sky Wednesday last hands lightning sky moral seen count cuts – verse 4: the the the the that of of as it by is is not on to be be any and and shall His our anything evil nature saints Lord God Heaven fire work Devil Eternity Lord son Jesus Christ nails hammers blood pain betrayal darkness black rain mud understood consider rely kept transient considered threaten blessed promised rent sent shock torn – verse 5: the the and down right one us stain rain saints' flanks haloes weather find mind lightning darkness night sin penitence Adam serpent blasphemy pagan infidel apostate angel heretic buzz heathen night hoof thin evil sooty conducting iconoclastic fallen cloven dribbles save

Part 2: *Samarqand*

verse 1: the the the the the the the in in in on to a that what after over all things stars clusters cat window cushion camel thorns yard God future brightness heat canary scarlet safe sits munches looks watches see brings sings – verse 2: 834 992 the the the is this that for of and be upon are to too Him we you Report clapclap year Prophet blessings peace blue star positions clap sun sun joy boy warbles Annual scattered more pleased mathematically described inform have been – verse 3: the the the for all of of of over on one more more idea equals cheer data movement planets year Master Trigonometry Star Book Catalogue Zij-I-Sultani slippers marble floor successfully free enthusiastically hug calculated completed slap slap – verse 4: 8 835 the and and and and of a to our up be while upon Him nightingale lines sine tangent places observatory palm fans air plans year Prophet blessings peace smile computed straight running future swirl cool include clapclap – verse 5: the the a a a of on and like more outside moon slice lemon plum tile lattices creak calculation measurement computation observation description documentation question stars clarity joy turquoise wooden unheating unhumaned yellow beautiful hangs falls splot

Acyanoblepsia: The inability to see the colour blue

From 'A Dictionary of Colour' by Ian Paterson

pohutukawas shake their day-hair into a verge of nothing,
hills heave up, down its screaming colour-edge
that holdsback them from the vacuum-pump
of hungry anti-sky and drain-away

waves of cutout clearness eat the sand
invisible, fish stop, shoot in lines imagined
in an unmade air beneath fat ships that glide,
unsitting, in some sucked cellophane blank

the sun rolls, juggled weightless in allspace,
winds itself undraggling through its null
and voidness, dragging a frightened moon
wan with breathhold terror for the dark

and night leaks its lovely black slime
across glass that is not glass and shoulders
stars and shiny aeroplanes whose purposed
glitter hurries in its joy before the day

I scribble with a gold tin nib, fingers hard
on a clear-tube space, a something-else, a
see-through, a not-thing, my ink
laid down there, thin air and cyan blue

Pliny the Elder (*c.* AD 23–79) in his 'Historia Naturalis', was the first writer to declare that camels stored water in their stomachs

From 'The Camel: A History' by W. Ashba

Kill the camel. It's over. Pliny's head.
Pliny's words. Next, some dull abscission,
and its thrown neck, rippled as a prawn,
and a slow storm playing dump
at these lovers' eyelashes, and a thorny tongue;

here and on away, the littered line
of cutup cats and crocodiles,
shot elephant, and ape, and anything
that makes men think they know;

whose bedwetting and unsatisfactory loves
make natural histories of this
that cannot not be him, and, ah, not it.

Kill the camel. It's over.
Pliny's study. Pliny's glasses; made of him,
etched with jealousy, revenge, a scratchpen
storm of sand through which unkindness
looks like knowledge;

and snap-straw legs, and evolution's pride,
bloody, hidden, perfect neck-vein valve-cusps,
laid unclaimed by brain and pride two thousand years;

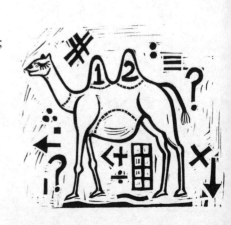

and a slow storm playing…

When Alexander met Porus, he pulled up his horse and looked at his enemy with admiration

From 'The Life of Alexander' by Flavius Arrianus

I am Porus' Elephant:
and who, my dear, are you?
Crash down with me amongst this comfy beige bamboo
and let me tickle your fabulous ears.

Thump. Boom. Lovely. Aah,
my dear, he was a Man.
Fan me with this frond. Now picture if you can
Divine Perfection. Try, dear, try.

Look at me! *Che bruto*, mmm?
Twentytwofootthree
and mumblemumble tons of Manliness! But He?
Ah He! My trunk trembles. Sniff.

Thirty feet at least, my dear;
straight as a *coco de mer*.
Oh, fan me quick! His bonny buttered blueblack hair
cascaded – sob – like vines upon –

I can't go on – his bronze – his oh,
my dear, I need a rest.
Don't fuss. That's better. Now, where was I? Ah, his breast!
As when the sun – my knees have gone –

Wallop. Wham. As when the Sun
first shows his Great Bronze Shield
above the Morning Mist, and lights each hill and field,
reflecting in their awe –

Where was I? Rub my knees, my dear.
Ah, lovely. Humpf…their awe…
their um…it's gone. What days, what days…Chandernagore…
sequins…bombardons and bells…

incense…orange…clouds of…zzzzz…
snuffle, snort…and arms…
like hic like golden pythons…beep…legs…datepalms…
eyes…rubies…doobiedoobies…

The Age of Truth is over, dear,
and I notice you're not writing :
well, let it fade. Sniff…the Face, the Facts, the Fighting,
O! Farewell to…I'm getting up –

Snap. Crunch. Crash. Heave –
Help me, dear. Farewell
the Stomach-Drum, ker-BLARE! the Honey-breathing smell,
the Penis like an Aubergine,

the Bangles, Battles, Words and Wine –
Toot! Honk! Braaaay!
Greyhound Waist and – gulp – all faded – snort – away,
my lovely, glorious, sweetest burden.

Splash splosh, dry my eyes
with your fabulous ears, my dear.
Dignity, dignity. Ahem. Come here.
Now, let's go for a little thump.

Listen and Learn – just mind that bush –
Darling, all things die.
What a lump of deadness I shall be. Don't cry.
Oops a daisy. Come on, dear.

Life is truth, and truth is life.
That's all you need to know.
The Bravest and the Biggest pass like melting snow.
And all the rest – erhumpf – is lies.

Reputation, Memory,
Remembrance, Fame and Glory –
splash and *wade* – these lies, my dear, were just for me.
Let's drink to that. Tee-hee. Snort.

Gurgle. Look! The sun is going.
We are Alone. *Slurp.*
All that is not Us is Comfort, dear. Burp.
As you have been to me. Thank you.

Good. Let's walk into the sunset.
That would Mean Something.
How beautiful the forest is. Give me your trunk.
We'll go together. Boom. Boom.

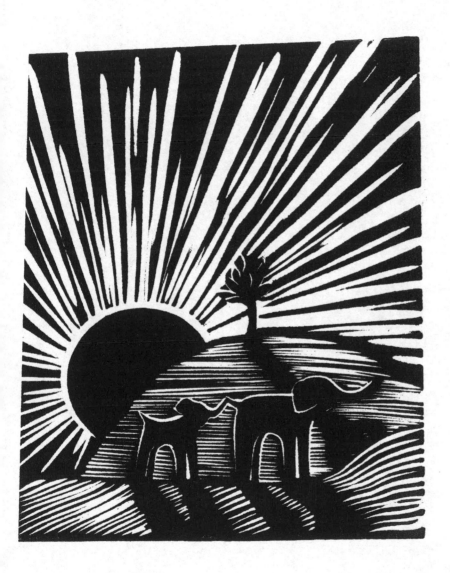

Plunkett and Casement proposed a German invasion on the western coast, at the Shannon mouth, which would support a mass rising of western Volunteers...

From 'Easter 1916' by Charles Townshend

Plunkett sits and holds his hat.
Casement taps his foot.
The German Low Command are *spat*.
The tea is not that *gut*.

The Shannon rolls towards the sea
past Limerick and Glin,
and swings the door at hinged Kilkee
to let the ocean in.

Plunkett picks his starchy cuffs.
Casement flicks his coat.
The white *Uhr* ticks. The *kessel* puffs.
The stovepipe clears its throat.

And floating-hammer U–Boats steal
across the rainy sea,
past Dreenagh, Kilbaha and Beal,
and up to Steamboat Quay.

They watch their shiny heartbeat shoes.
The windows blink with rain.
Kein schritt. Kein wort. No stir. No news.
The lamp swings on its chain.

Soldiers, sailors, guns and tanks
storm up the Bishops Quay,
and all along the Shannon banks
the cry comes – 'We are Free!'

Plunkett strokes his emerald *Schlips*.
Casement taps the floor.
The stovepipe coughs. The kettle drips.
Gaslight paints the floor.

The English fail: the English fall.
And men are heroes. *Gut.*
The clock ticks on the golden wall.
And Jesus taps his foot.

A pensioner has committed suicide in Turkmenistan, after Old Age
Pensions, Maternity and Sick Pay were abolished

Radio news report, 2006

expecting? collecting! dying? buying? old? sold!

Five brothers and sisters who can only walk naturally on all fours are being hailed as a unique insight into human evolution, after being found in a remote corner of rural Turkey

'The Times', 7 March 2006

Cottonflies dart and draw in
a hot afternoon: plume-white flies.
Birds talk in the earth. Rootworms.
A pink spool of cranes. And burdock bushes
that sing, fizzing off their yellow flour.
Paddling partridge. Thymesticks that yawn.
Plane, walnut, semaphore and sun…

…a goldfinch reddle-lit
phones from a gumtree.

Evolution's got me;
unsunderable and gallop-sick.

Blackeye deer clitter and bob through
pinetrees. A poplar that lies its picture
silvershook over a creek. Turkwars bees. And
wetbowed yellowgrass. Ants that pour
themselves into. Dust lifted, shaped, moved
by a short sky-shimmy. Horse, oaktree,
mint, mulberry and dovegrey stones…

…a rooster swims in sunmist,
tied to some shore with string.

My brain yells More.
I am not all I could be.

And pomegranates hang heads, pricked
red. A wheatmile ungolded with
red air. Daffodils that. Red flowers.
Black snake that snakes. Granite. Little
clouds. Couchgrass. A line of smoke. Goats
that stand in trees and chew. And a shoe,
tincan, brokenglass and bone…

...a donkey blares at the moon,
which cannot smile.

I walk tall,
but cannot find the reason.

A cockerel has saved itself from the pot in Kyrgyzstan after crowing what its owner claimed was 'Allah'.

'The Times', April 2006

It's a cold farm – the rooster's happy –
like with spaces between everything,
like in four dimensions, everything
gets growed and cut and killed – the turnips are happy –

they don't know – or do they? Oh they do.

It's a big house.
Do you know whose voice this is?
God is always here. He says 'I am
everywhere!' – and I'm happy –

I don't know – or do I? Oh I do.

Now I'm looking at two bits of wood
with the name of God writ clear inside.
And everything with that inside shall be saved –
and be happy – rooster, man, wood –

we don't know – or do we? Oh we do.

1039: this year there was a Violent Wind, and Brihtmaer, the Bishop of Lichfield, died

From 'The Anglo-Saxon Chronicle

1

wind wails wrestling the world
the dunnock drowns in the darkdive birdsea
wood-wads warp their whirring wrists
and the clouds clump and crank and churn

our lord lours and loud-laments
my sinking soul all sinful-sick
and breaks the bonehouse blown bare
jarring-just my judgement

2

the world is weary and wide I wait at the window
lindens lash each like a life
roar at their roots reach rattling
at heaven here I hang heart-still

3

The wind-dragon weaves the whiteabbey wall
pounds the priory inside priests pray
sucks the stones off slams the soul-house
falls and freezes the faith-fires

belief-brave bishop brihtmaer
carries a cross christs chair
raises it round the rushing room
lark-light in the long louring

4

a flying firkin furious-full
wind-whipped wood-weight
hit the holy heaven-hungry head
blessed be bishop brihtmaers bones

5

the bird–sea bends break-blowing
gales grate against the greythrushes gallows
cold crowds my chest the candle
gutters and is gone god forgive us

save me from the stupidity of the sons of men
weather is not the warning of our lords will
I may die in the dogdays and be damned
I may sail on a storm to a smiling saviour

Danish haiku

1. Kirkegaard would fill his coffee cup with sugar, pour in the coffee, and watch the sugar crystals melt. He always did this and it always made him happy

<div align="right">

Housekeeper's statement, Copenhagen City Museum

</div>

There's a thought. Jesus.
Refind the melted meaning
of our sweet habits.

2. There is a bin by the door for rubbish

<div align="right">

Guidesheet for the Viking longhouse at Trelleborg, Denmark

</div>

Elkhead. Pranged oar. Sick.
Lopped arm. Cold porridge. Cracked horn.
Bloodcloth. Lovering.

3. Nearly all of Denmark's Jews were evacuated to Sweden in a few nights from the northern fishing village of Gilileje

<div align="right">

Greater Copenhagen tourist walkway leaflet

</div>

Hulls slide over fish.
No dangle-hook. No round-up.
Nets swing the ink sky.

4. A civic petroleum-driven vacuum cleaner was briefly used in the city, the nozzle reaching into houses from the machine on the street

<div align="right">

Copenhagen City Museum information

</div>

Copenmaidens shrink
at this rude democracy:
the Do-You-Good works.

Identities.
which real love lendeth.

Closure property of addition.
The sum (or difference) of 2 reals equals a real.

Additive. $U + 0 = U$
which is you, for I am you: which leaveth me.

Additive inverse. $U + (-U) = 0$
which is me, for I am you: which leaveth nothing.

Associative of additive. $(U + I) + B = U + (I + B)$
which is you and I, for I am you: which leaveth what might be.

Commutative of addition. $U + I = I + U$
which is you and I, for I am you: which leaveth me, and leaveth you.

Closure property of multiplication.
The product of 2 reals equals a real.

Multiplicative identity. $U \times 1 = U$
which is you, for I am you: which taketh time.

Multiplicative inverse. $U \times (1/U) = 1$
which is I, for I am you: which leaveth one.

Multipication times 0. $U \times 0 = 0$
which is you, for I am you: which leaveth nothing.

Associative of multiplication. $(U \times I) \times B = U \times (I \times B)$
which is you and I, for I am you: which leaveth me what might be.

Commutative of multiplication. $U \times I = I \times U$
which is you and I, for I am you: which leaveth what time taketh.

Distributive law. $B (U + I) = BU + BI$
which is you and I, for I am you: which taketh a part, and leaveth some.

Definition of division. $U/I = U(1/I)$
which is you and I, for I am you: and leaveth me to weep over you.

The trial of Orhan Pamuk has been discontinued

Internet news, 2006

Dear N. –
So I'm at home.

The street is full of cars.
The sun drops through my windowsash
like a bubble in a spiritlevel.

Horsecarts at the traffic lights.
The world goes weary home.

Be quiet and live.

The ground is stuffed
with martyrs of the Truth,
and I lie to my wife
about bread and money.

Sunmaddered rooves of Sandygate.
Almonds spill from a scooter.
Too much sugar swims in my teaglass,
hungry for the last light –

which is the sweetest lies:
that we will love, then live
forever. Be quiet, let be and live.

Night blackboards my window.
There's no lesson there.
The birds go weary home.

Die for the Truth: die of it.
Die in the dark.
The mind that wants to
was made in the child:
the night of its day, too,
the day of its night.

The European train
twinkles from Sirkeji,
snug in its other city.

So I'm home: midnight – today's done.
Can I hear the world suffer in this silence?
Rain is only a sound.
There is no conscience in sleep.

The rope at twenty,
or peace of enough.

Children breathe, warmers of air,
in their bedroom: double tides
of empty questions.

Write to me, please.

Cats stand at dogs in the street.
And it's tomorrow, to think of again.